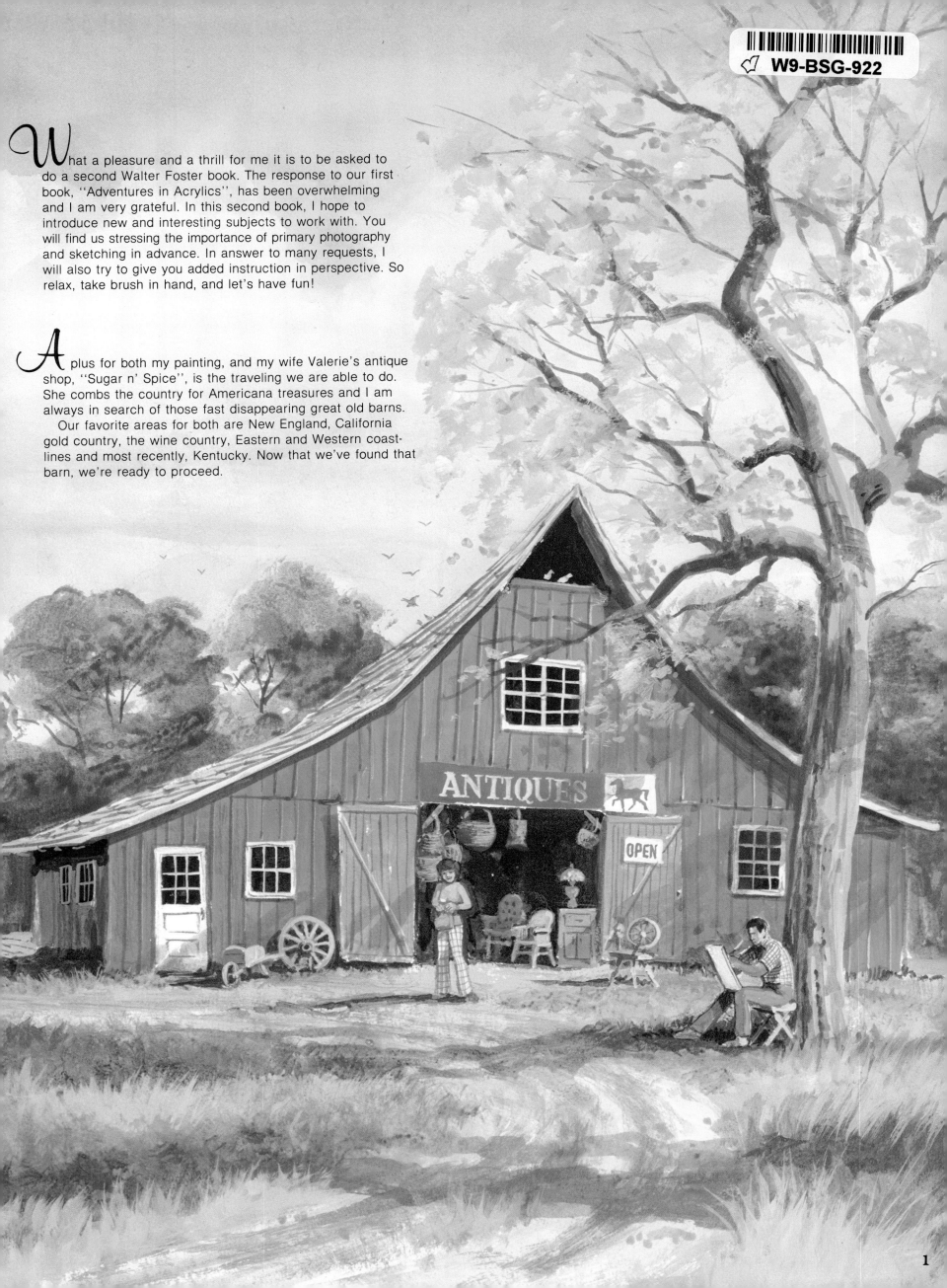

What a pleasure and a thrill for me it is to be asked to do a second Walter Foster book. The response to our first book, "Adventures in Acrylics", has been overwhelming and I am very grateful. In this second book, I hope to introduce new and interesting subjects to work with. You will find us stressing the importance of primary photography and sketching in advance. In answer to many requests, I will also try to give you added instruction in perspective. So relax, take brush in hand, and let's have fun!

A plus for both my painting, and my wife Valerie's antique shop, "Sugar n' Spice", is the traveling we are able to do. She combs the country for Americana treasures and I am always in search of those fast disappearing great old barns.

Our favorite areas for both are New England, California gold country, the wine country, Eastern and Western coastlines and most recently, Kentucky. Now that we've found that barn, we're ready to proceed.

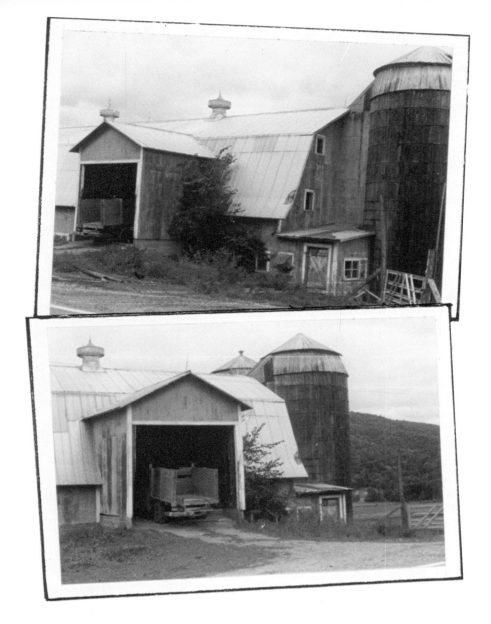

THE IMPORTANCE OF SKETCHING BEFORE PAINTING

Good photographs of your subject are a must before you begin your sketch. Polaroid pictures are great if you want an instant print, but any camera will do. I like to use a telephoto lens because you can't always get as close to your subject as you need to for detail. Take pictures from all angles. This gives a good overall view. You will also need good photos of the accessories too; such as mail boxes, milk cans, fences, weeds, etc.

Now you're ready to make the rough sketch. Using a number 2 pencil, be aware of a two point (or more) perspective. One of the biggest problems many have with a barn is the shingles on the roof. They must follow the angles of the roof and give an over-lapping effect.

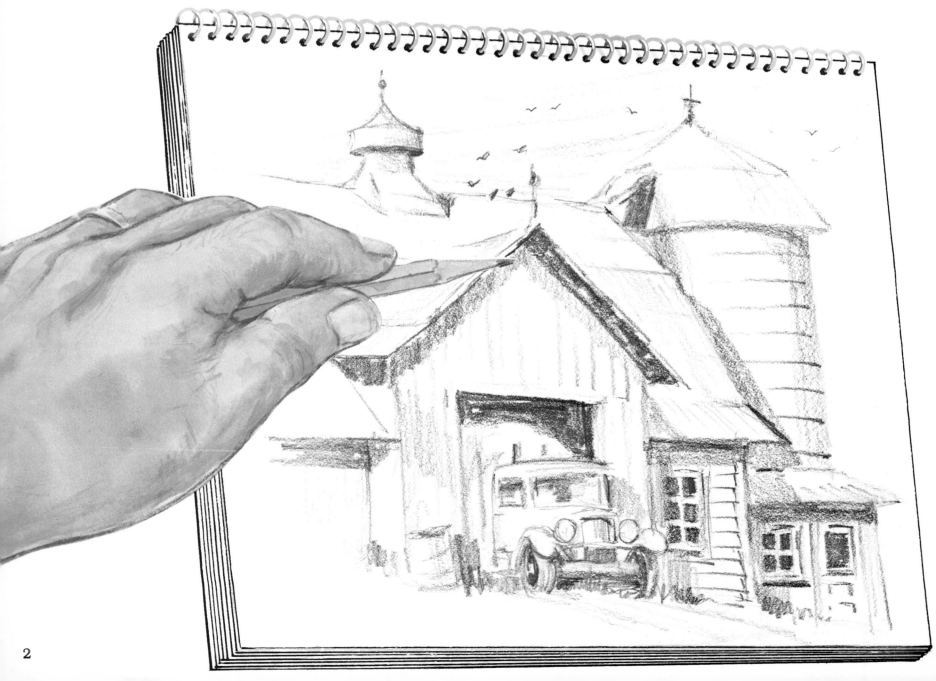

PEN AND INK

Ball point or felt tip pens are both good for this type of drawing. This is a much tighter sketch than the pencil roughs. Pen and inks are lovely by themselves, as well as a valuable aid to a finished painting. When using this sketch as a prelude to your painting, make notes in the border for the colors. Pen and ink is great for details. It also has the advantage of being fast to do for on-the-spot drawing.

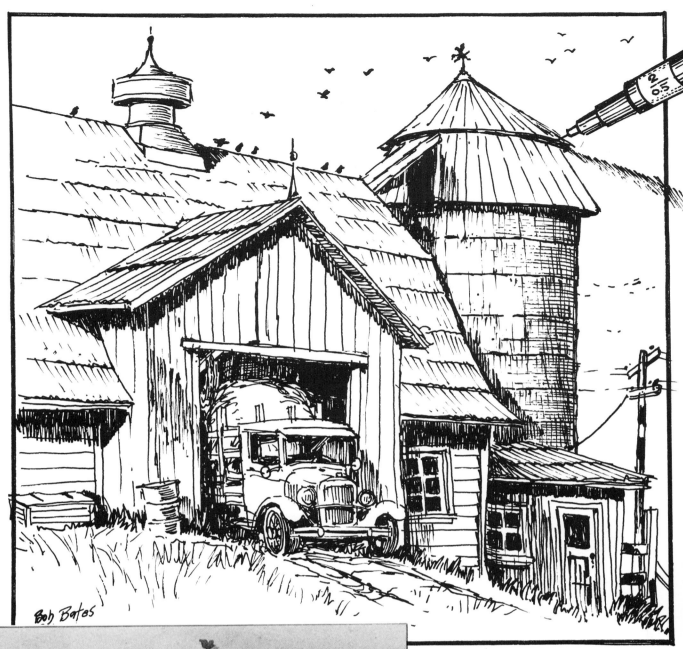

Bob Bates

WATERCOLOR PAINTING

As you can see, I block in colors in a watercolor sketch. Many of the "old masters" worked this way. You will finish the entire painting in a very rough form. This technique is also used in layout work for commercial art jobs such as brochures and ads.

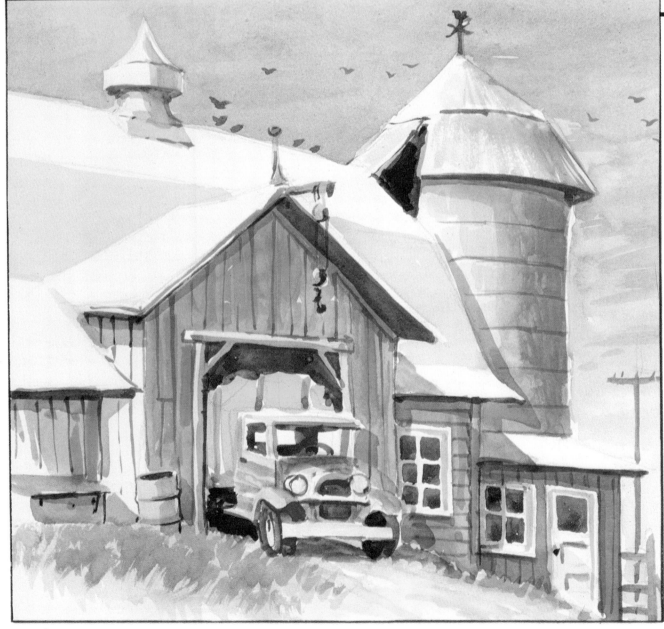

PREPARING
THE PALETTE

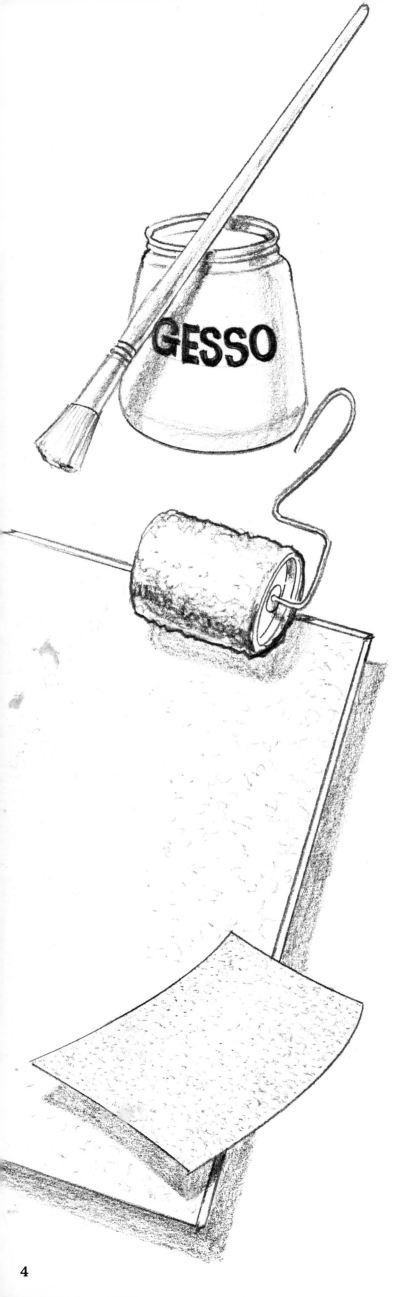

If you choose to work in oils, prepare your canvas or canvas board in the usual way.

Acrylics are very different, especially if you are using masonite. This is my personal choice. Working with un-tempered masonite, using a 1½ inch flat brush, paint the surface with a coat of Gesso. To achieve a good painting surface use a small painting roller, to roll on when it's wet. This gives a smoother finish and avoids the stroke marks that you would get from a brush. When the Gesso is completely dry, sand with a light sandpaper.

PALETTE

Fold a paper towel so you have three thicknesses and then place it on the side of a waxed paper palette. Saturate that towel with water to which you have added a retarding medium. Your paint will stay wet longer this way. Acrylics dry very fast without this retardant. I also use two water jars with retarding medium in them.

The covered bridge on the right uses most of the color combinations. It's also a good example of reflections in water.

Sky colors are White, Yellow Oxide, Blue, and Black. Flow down from dark to light.

Tree colors are White, Chrome Green, Orange, Burnt Umber and Black.

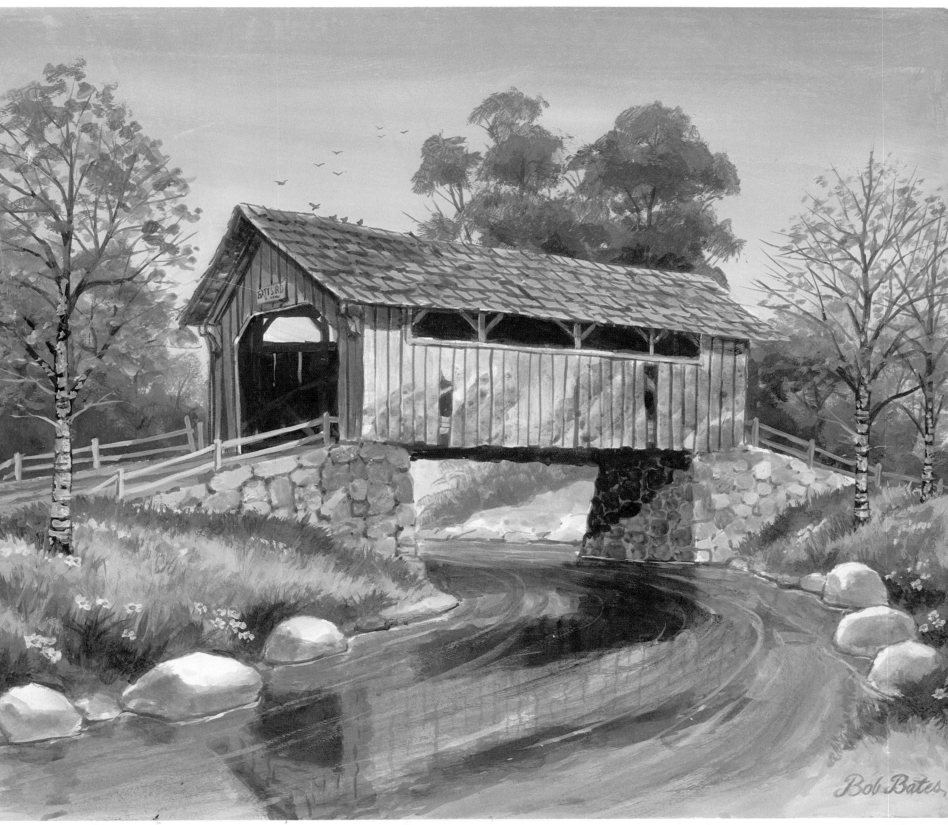

Ground colors are White, Ochre Yellow, Orange Alizarin, Raw Sienna, Burnt Umber and Black.

Water color White, Yellow Oxide, Burnt Sienna, Blue and Black. Good luck!

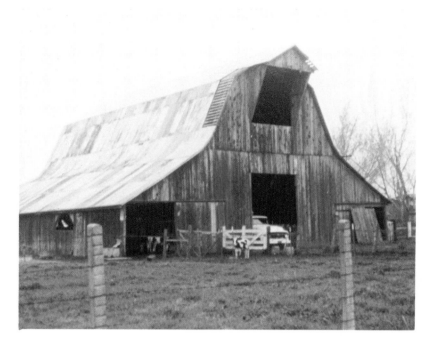

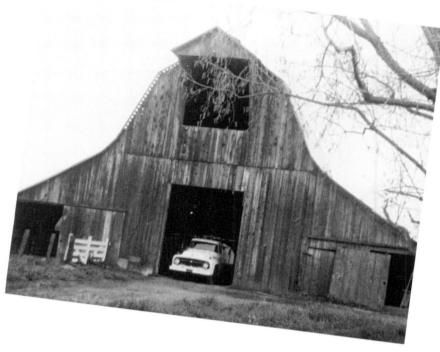

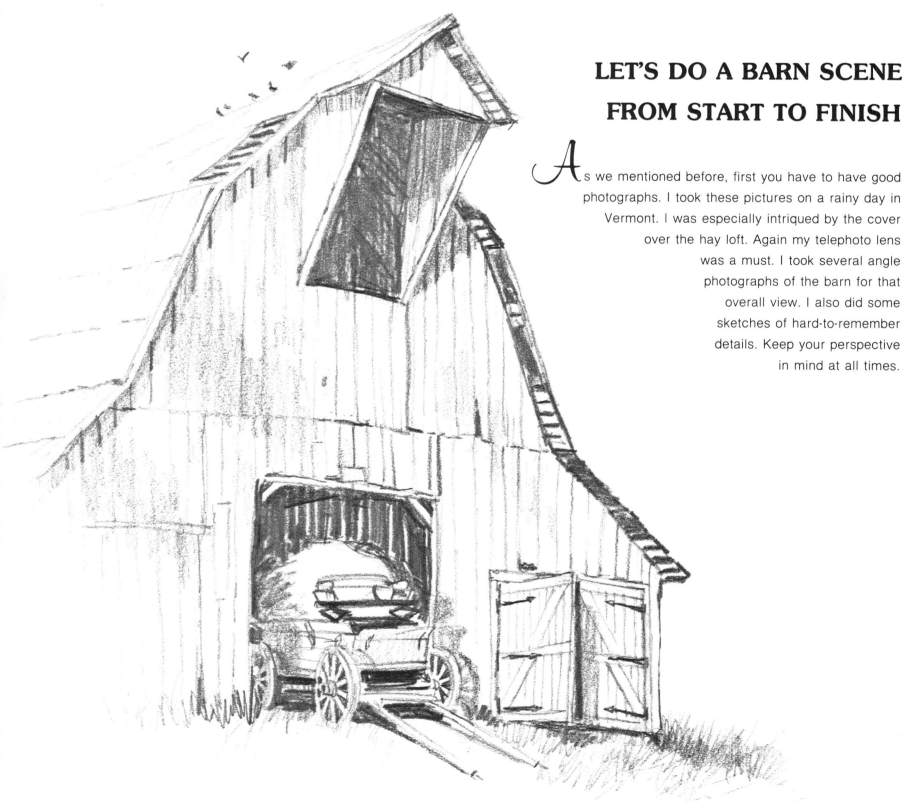

LET'S DO A BARN SCENE FROM START TO FINISH

As we mentioned before, first you have to have good photographs. I took these pictures on a rainy day in Vermont. I was especially intriqued by the cover over the hay loft. Again my telephoto lens was a must. I took several angle photographs of the barn for that overall view. I also did some sketches of hard-to-remember details. Keep your perspective in mind at all times.

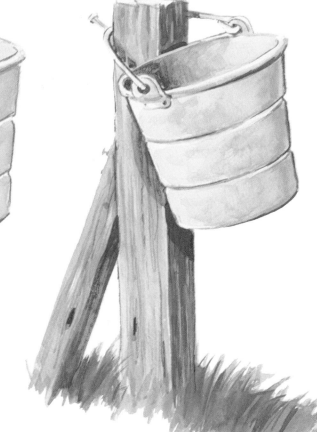

BARN ACCESSORIES

A bucket in the foreground is a favorite accessory of mine. We'll put one in this painting. Take special notice of the ovals of the bucket. To give the bucket third dimension, use a shading of light to dark with a back light of blue. Use oranges for rust and highlights. Also cast shadows on the fence. Dark behind light gives life to a painting. See how this brings the bucket forward?

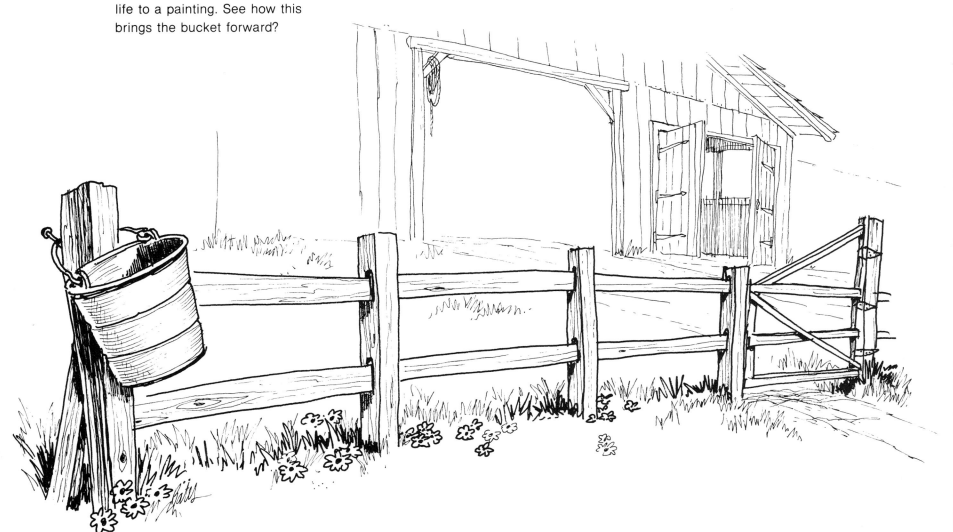

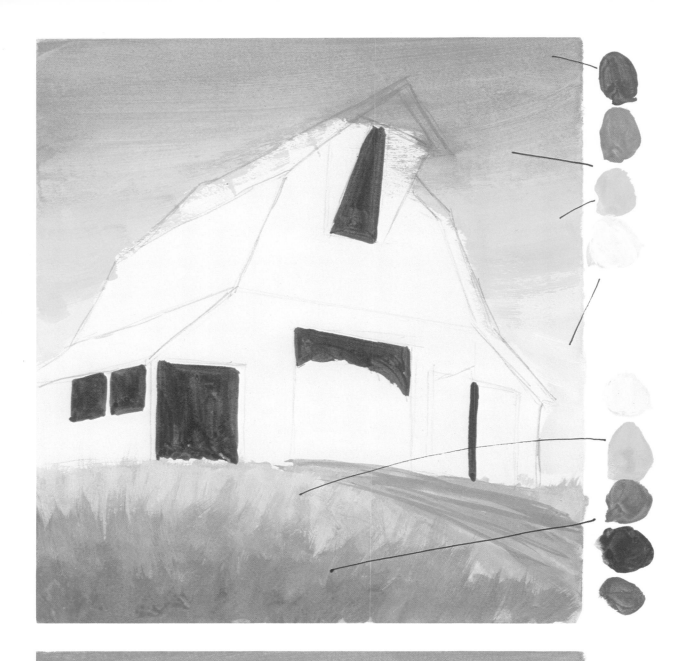

The sky is always painted first. This particular one is White and Yellow at the bottom and Vermillion Ochre at the top. Blend them together using a broad 1" flat brush and horizontal strokes. Now lightly sketch your barn in with pencil.

I painted in the shadow areas of the lawn with Black. Highlights will be added later for effect. The foreground is Burnt Umber, Black and Green, with Ochre for the dirt undertones.

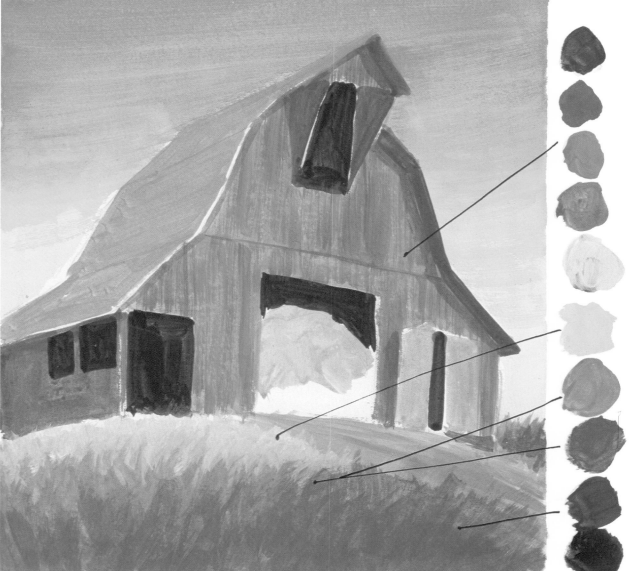

For the flat undertones of the barn siding you will need Orange, Red and a little Black. Use Green and Orange Ochre for the roof undertones. Notice the contrast of the dark barn opening and the yellow hay.

You can let your imagination go wild with the weeds. Always backstroke the grasses and weeds. Daisies are a must for me; they are discussed in detail in my book #186, Adventures In Acrylics & Oils/1.

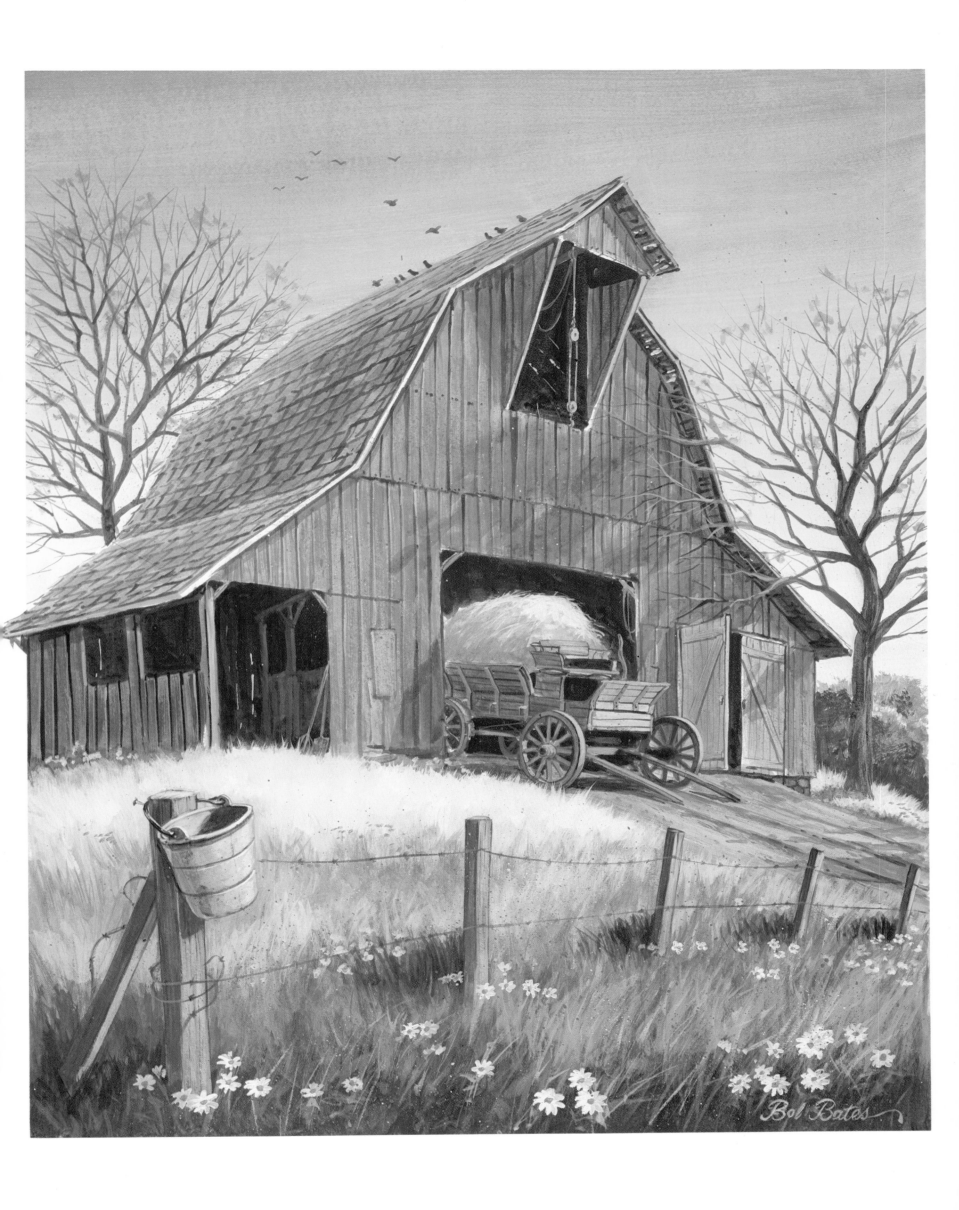

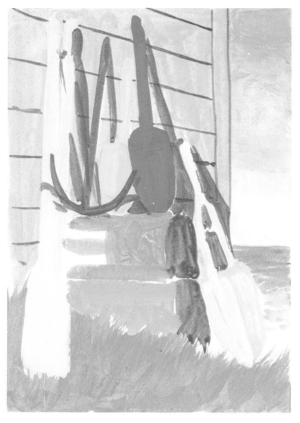

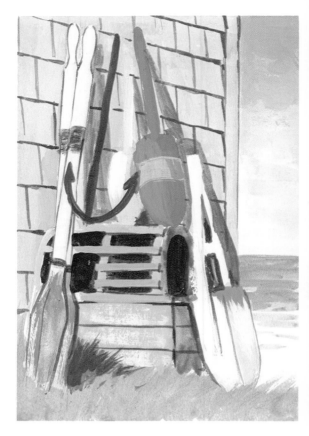

LOBSTERMAN'S WORKING TOOLS

In our previous book we discussed the use of seagulls in paintings of the seashore. Another interesting addition for coastal paintings, especially East coast, is lobster traps and the colorful floating markers. Oars, anchors, and traps are not easy to paint. Study the darks and lights of these objects very closely before you attempt them.

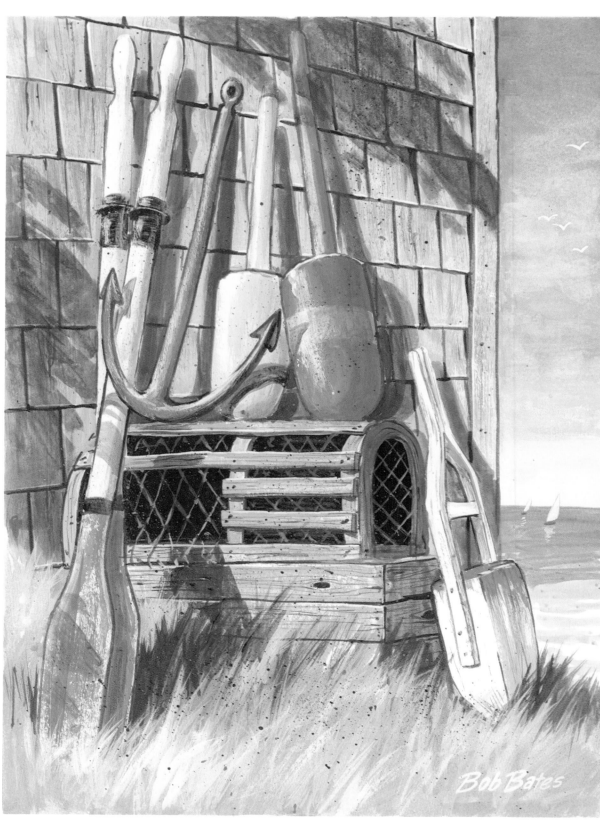

Bob Bates

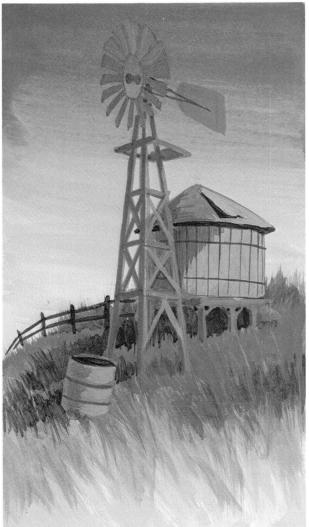

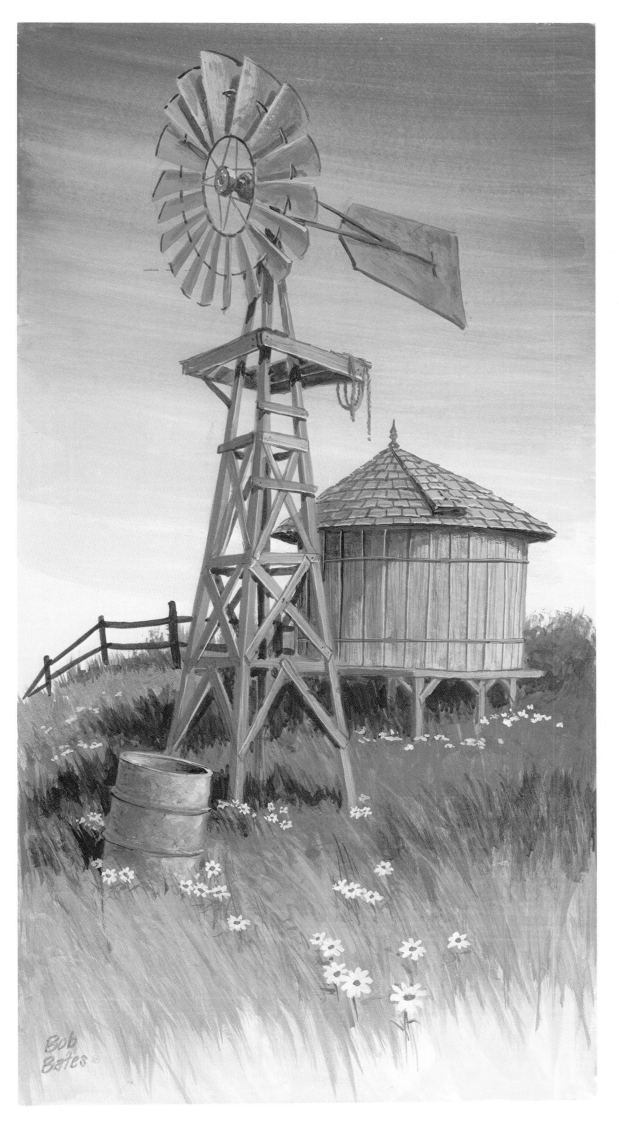

Bob Bates

The windmill is another great addition to a barn painting. The blades can be tricky. Notice that they seem to change position as they go around. The propeller is oval and the blades point toward the hub. Study the picture carefully and don't get discouraged.

Use Black, Blue, Burnt Sienna and White for the blade color then add a little Orange/Green for rust.

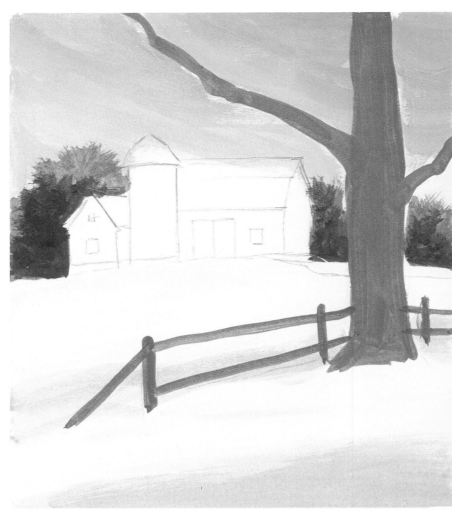

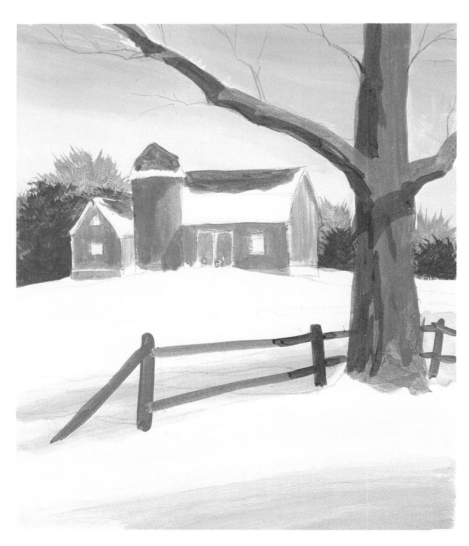

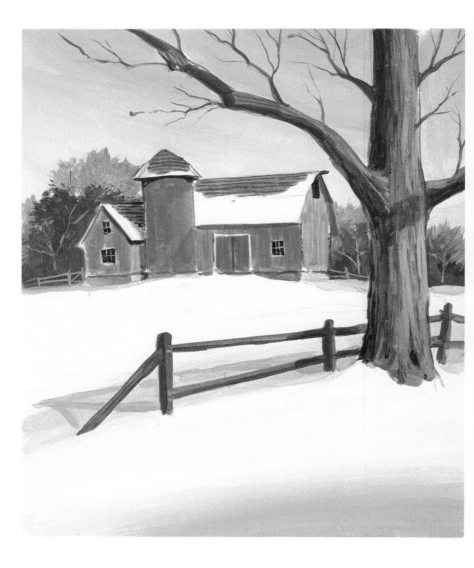

WINTER IN VERMONT

Snow paintings are fun to do! After painting in soft background color and lightly sketching in the barn, begin with the main subject and dark items such as trees and fences in rough form. Paint the snow White with touches of Blue and Black. Shadows in the snow are Blue, Gray and Brown. Have a few weeds coming through the snow.

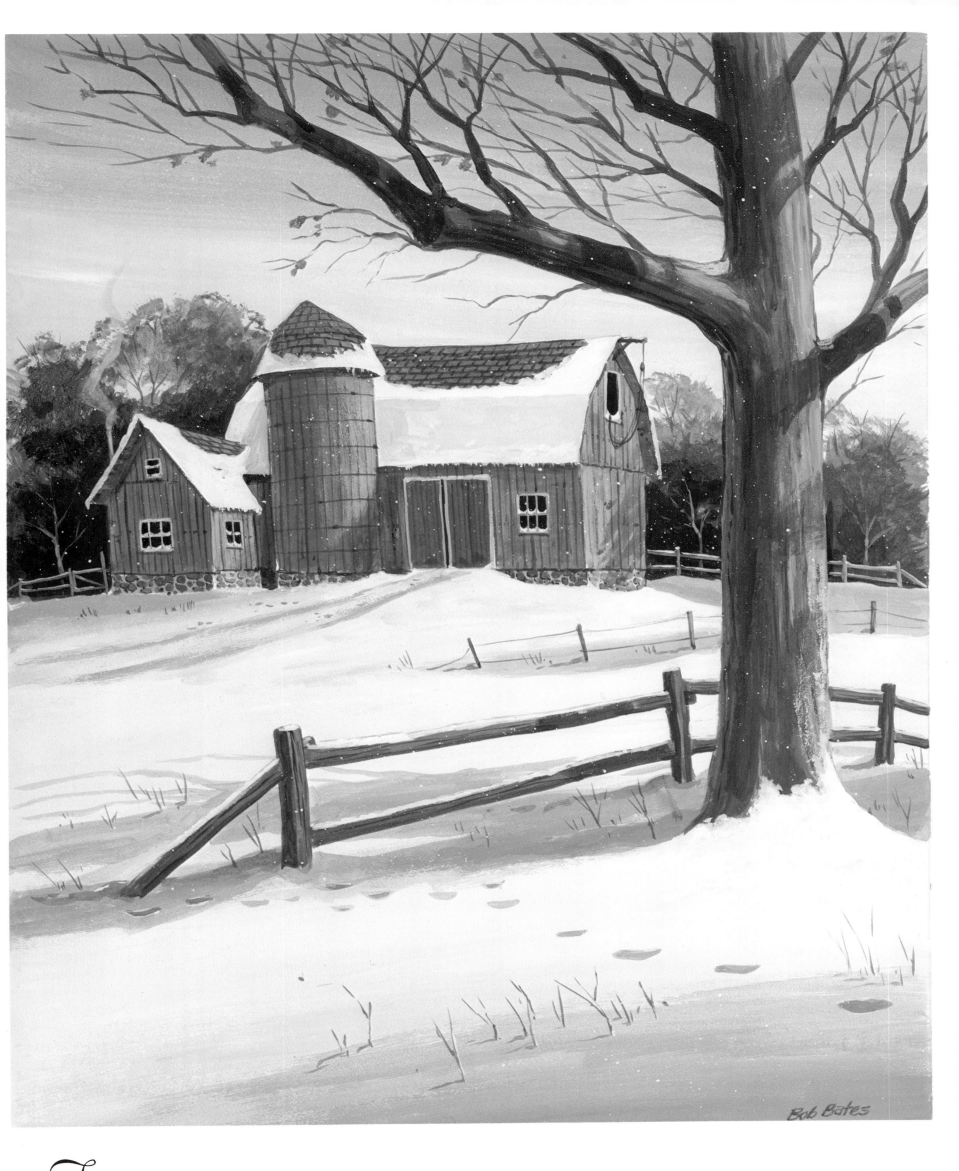

The snow is melting so you will see a few shingles on the roof of the barn. Perhaps you'll want to put a light in the window, or leave them all dark. With aid of a toothbrush, you can use the splatter technique for falling snow. Be sure to draw the stick toward yourself!

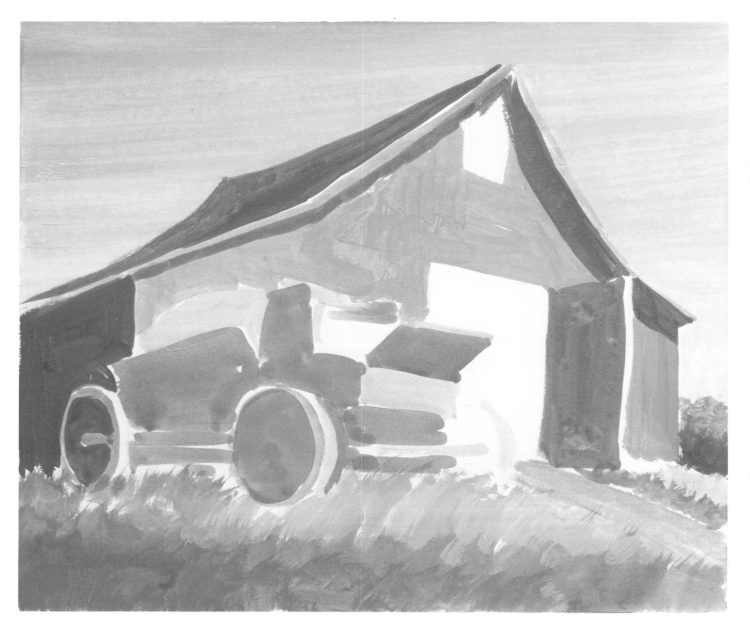

Before you get too far along with your painting, stand back and analyze it. Establish your light source. Where is the sunlight coming from? In which direction will you cast your shadows? These are the important details that add realism and a third dimension to your paintings.

In this painting I blocked in the lights and darks so I knew which direction I was going.

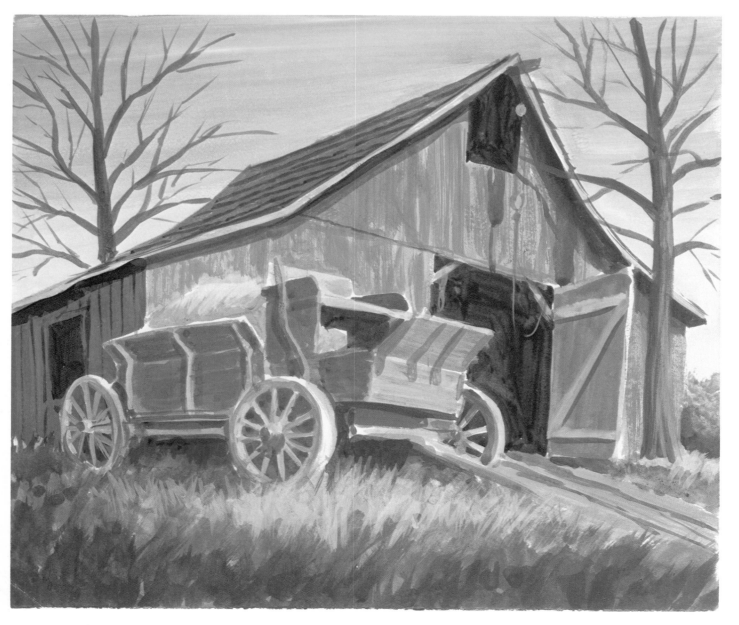

Now you are ready to rough-in the trees. Use a #4 pointed brush. Paint the tree branches away from you. Notice how they get thinner as they reach out. To finish the smaller branches, use a #2 or a "twiggy" with the same strokes. I added color (Yellow Ochre or White) to the top side of the branch as it crosses in front of the trunk. Your tree will achieve more roundness if you have a few branches coming over the trunk. Again, remember the importance of contrast.

THE OLD WAGON

My favorite wagon is from a photo I took at San Juan Batista. My mother was born here in 1897 and it is a painter's paradise as it is relatively unspoiled.

Be sure to keep your perspective in mind as you draw the wagon. Even the wheels have vanishing points. The back wheel is actually larger, but looks the same because of perspective.

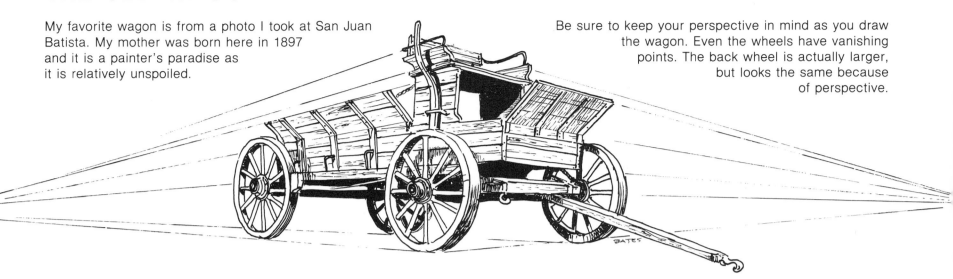

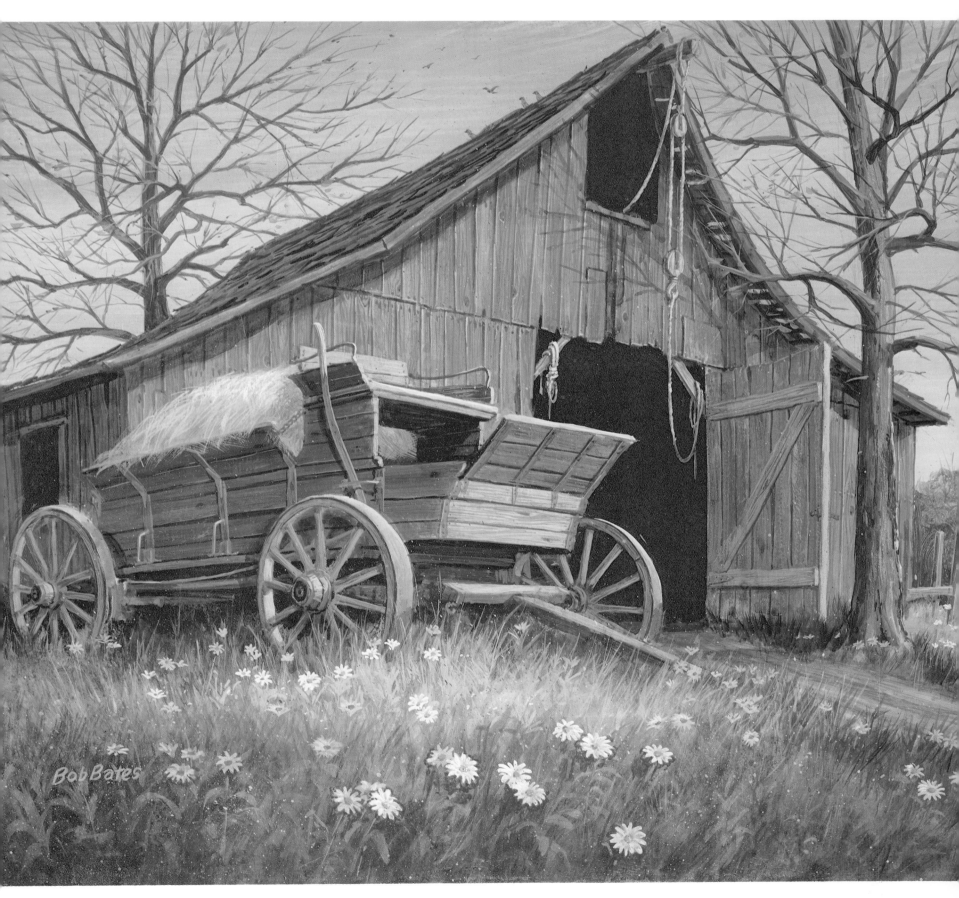

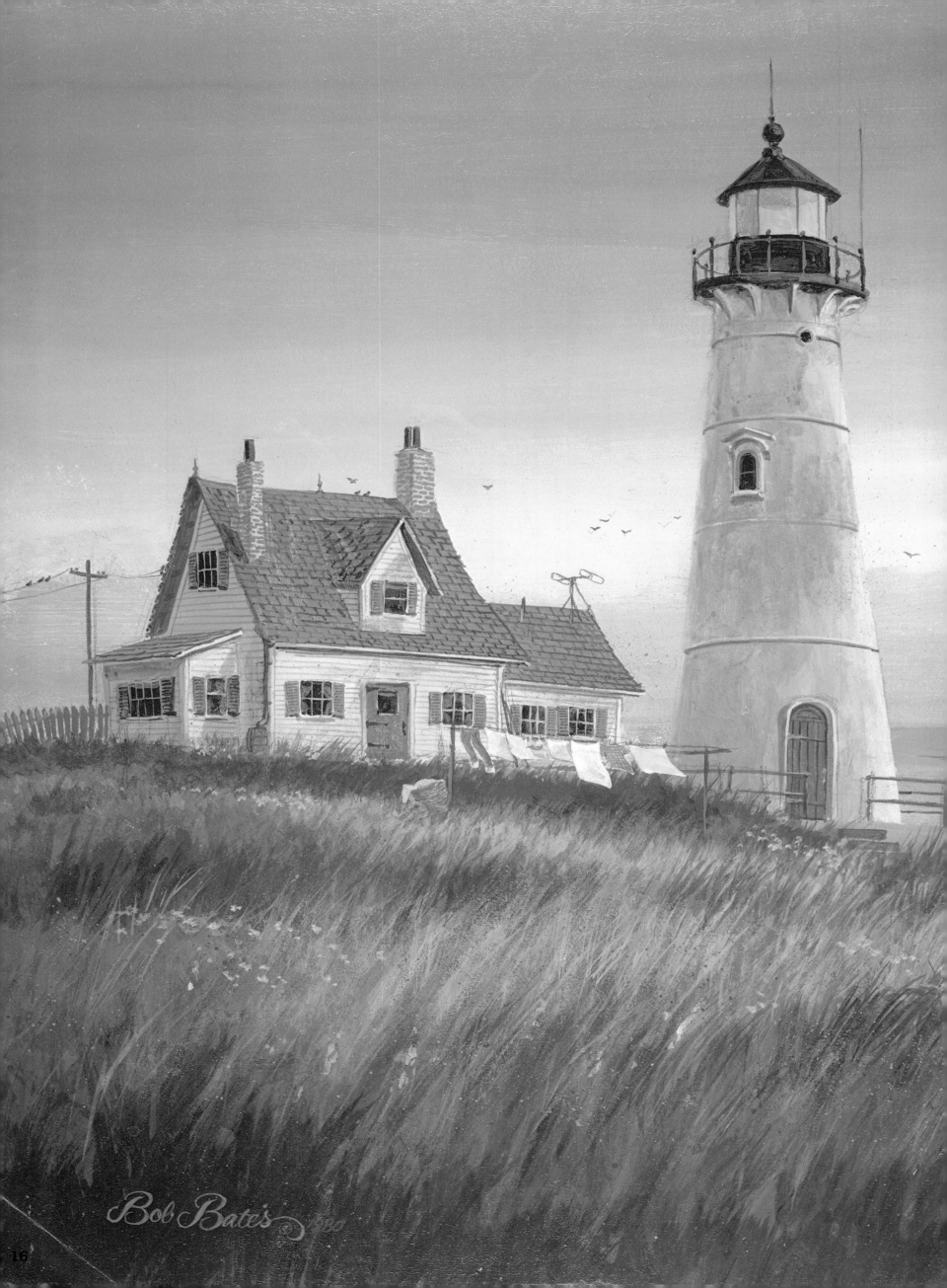

Bob Bates 1980

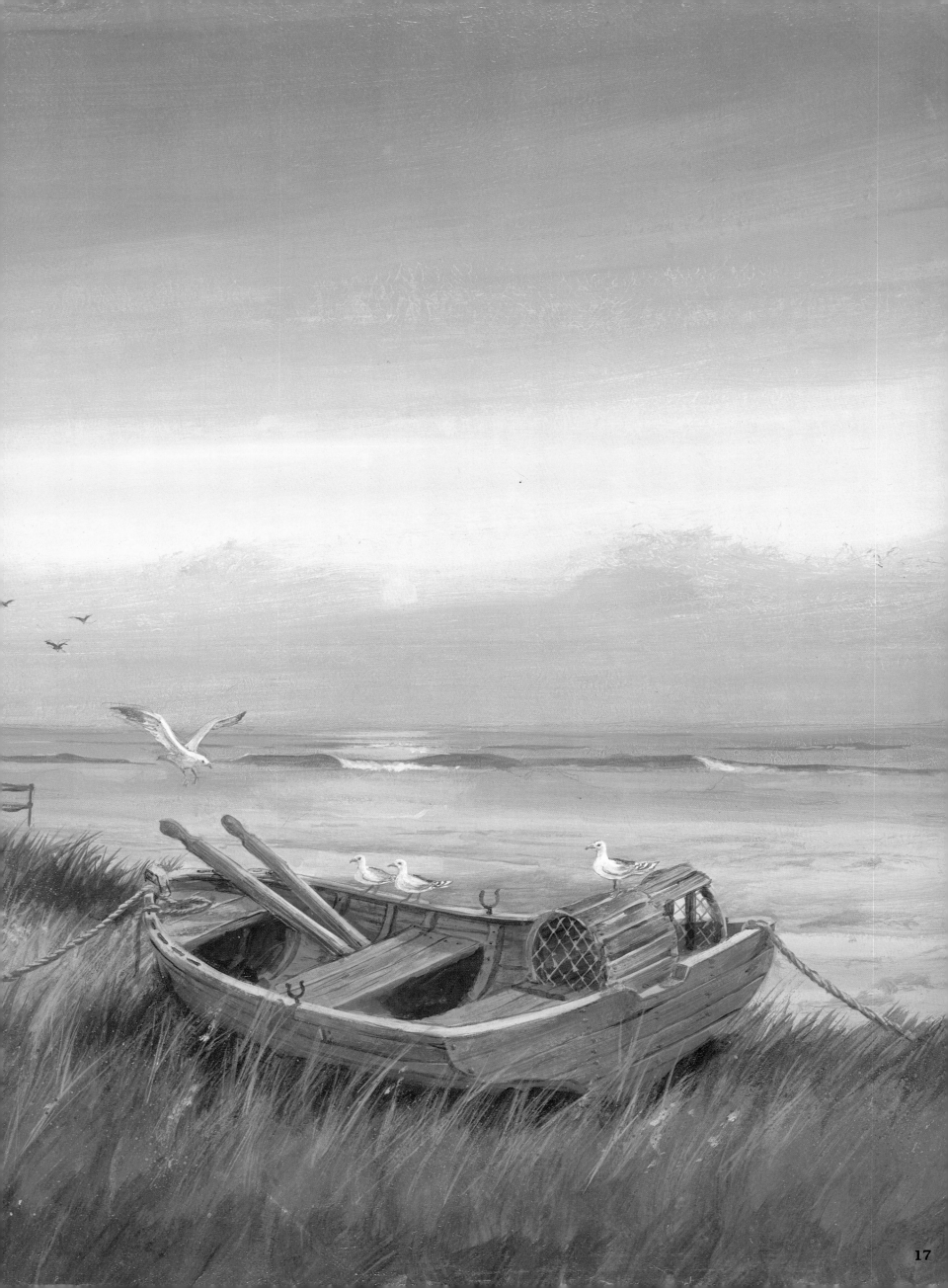

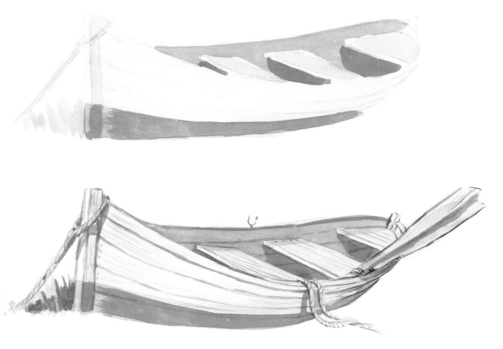

CAPE COD BOAT HOUSE

There's something about the lure of the sea. I love the call of the gulls, the fresh sea breezes, and the old fishing shacks and boats. They are a painter's dream! This painting is actually a composite of three sketches that I did in Chadum, Massachusetts.

Rowboats can be a bit of a challenge. Again one must study and observe. One trick to remember is that the oar locks and seats have the same vanishing point. I have given you five rowboats to study in this book.

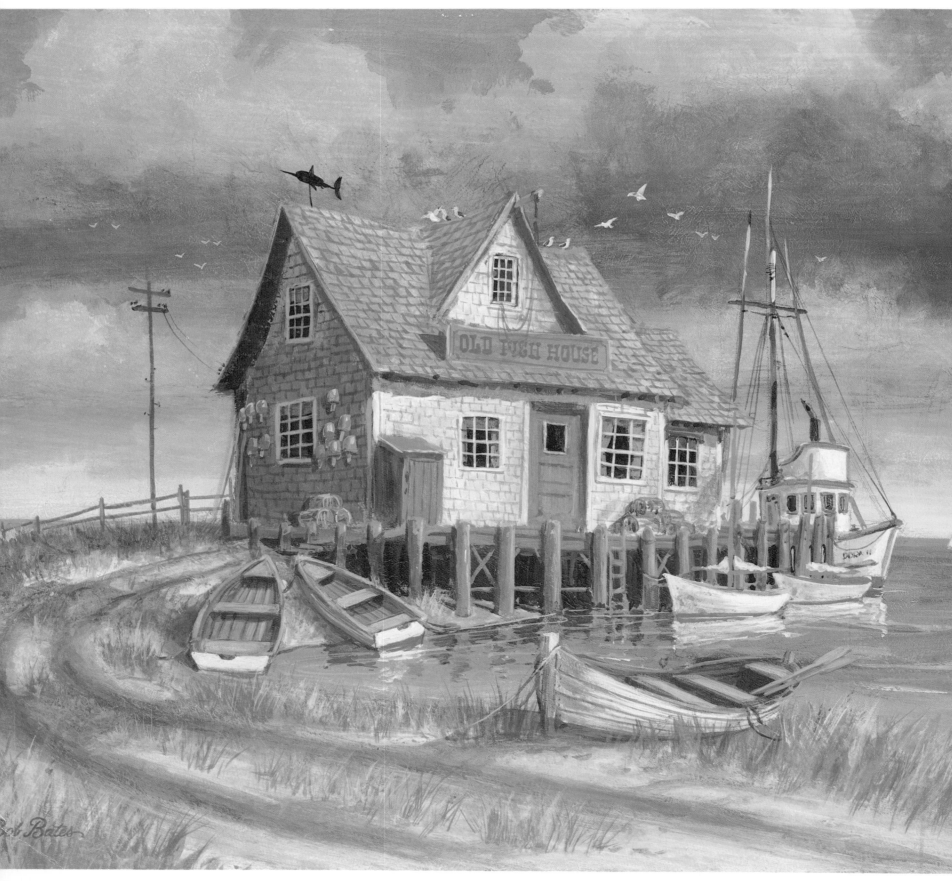

THE GRIST MILL

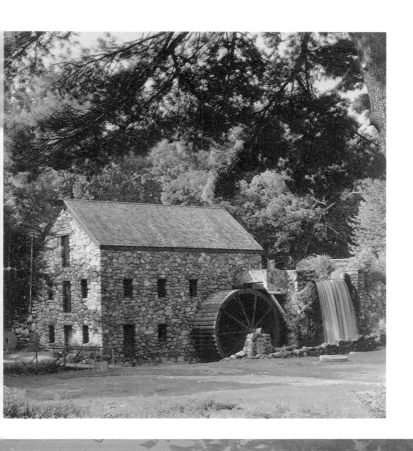

When I painted this mill from a photo on Maturity Magazine, I didn't know where the mill was located. In the Fall of 1981, we stayed at Longfellow's Wayside Inn, in Massachusetts. Much to our surprise the mill was on their property! I had made major changes from the photograph, but there was no doubt about it. I did change the small stream to a large pond for reflection value.

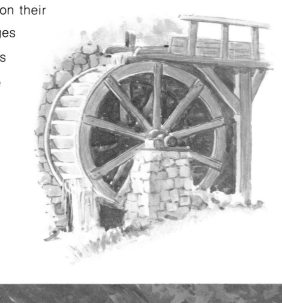

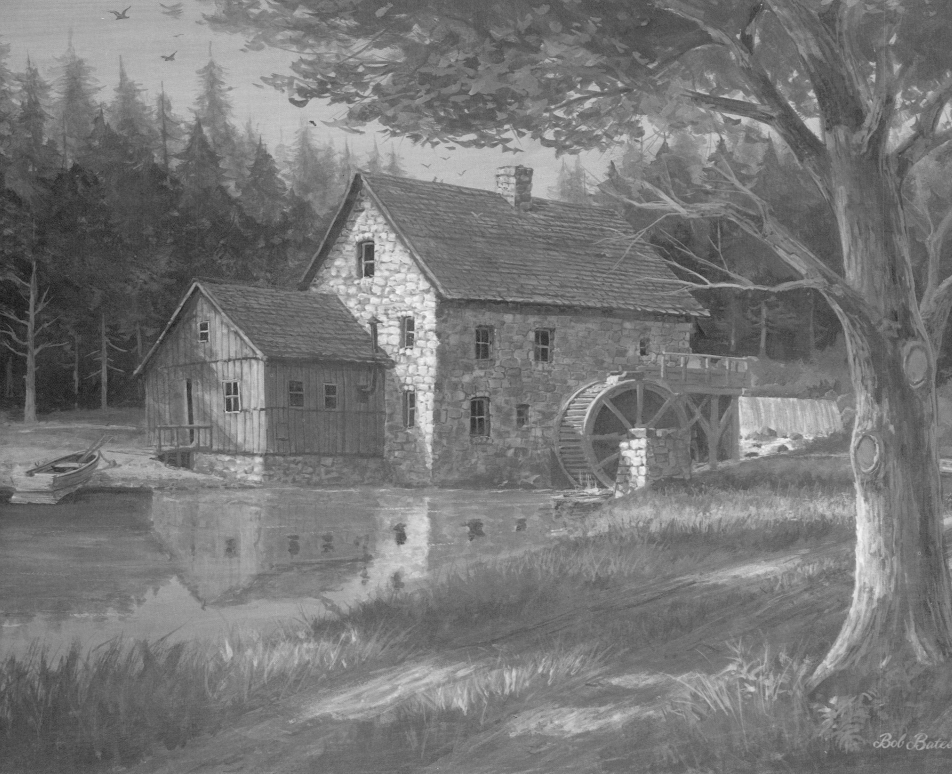

Bob Bates

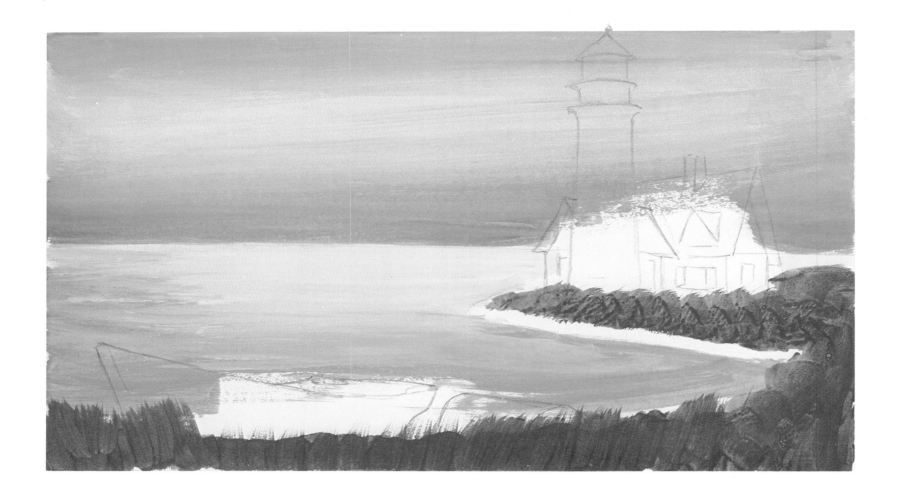

LIGHTHOUSE AT SUNSET

𝓘t's fun to experiment with composition. Everything doesn't have to be centered as long as it has a flow. Andrew Wyeth is a master at this. Although the lighthouse is way to the right, it is justified by placing the rowboat to the left. Note the oars point toward the lighthouse. I cheated with my source of light which doesn't hurt. You can see the sun is on part of the front of the lighthouse and the home along side it. Actually the sun is behind them all.

You may want to add more items around the foreground or none at all, just tall weeds blowing in the breeze.

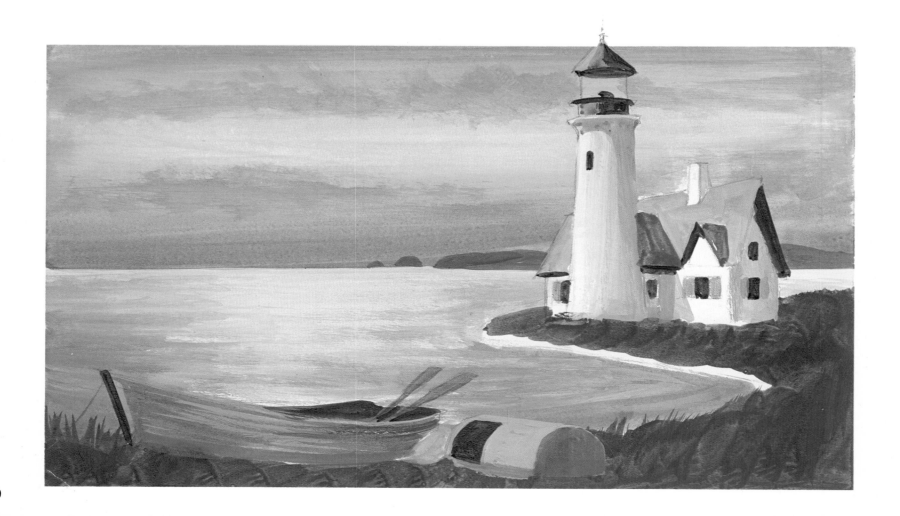

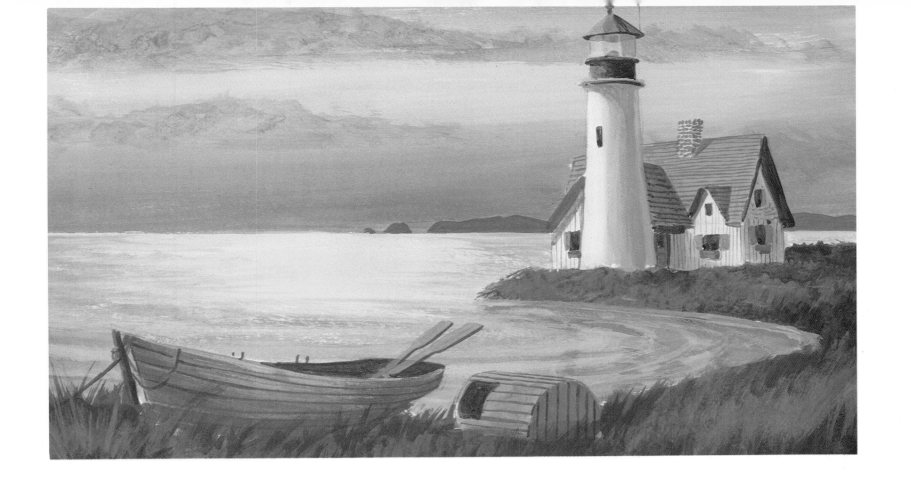

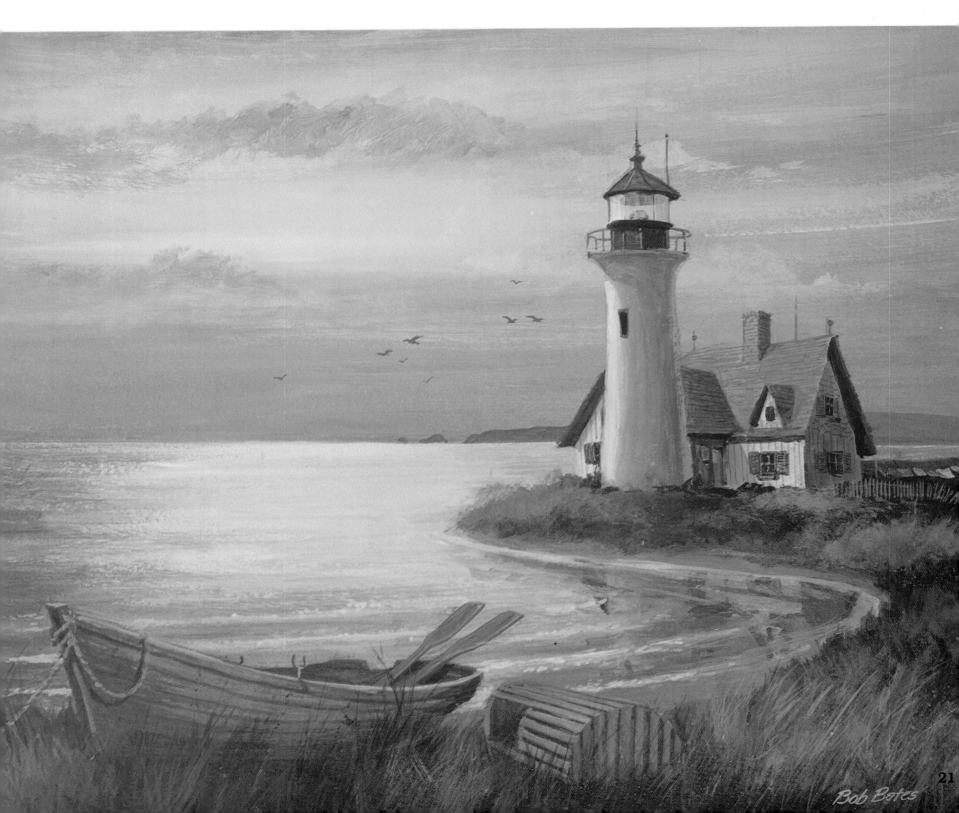

Bob Bates

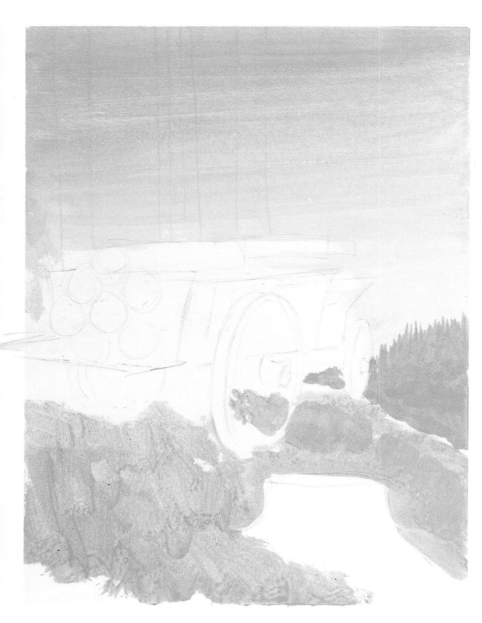

THE LOG WAGON

The weight of this composition favors the left, however, everything points to the right. I wanted to achieve the feeling of being high on a hill overlooking the valley. This is done by detailing your top trees to look very small. Use Green, Burnt Sienna, Blue and White.

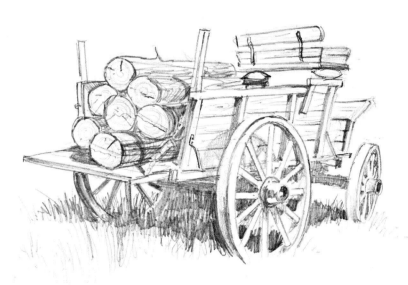

I lightly sketched in the wagon first and blocked in the scenery. We're now ready for the details of wagon, tree stump, ferns, and wild flowers for the final touch. A some stipple color here helps the finishing touches.

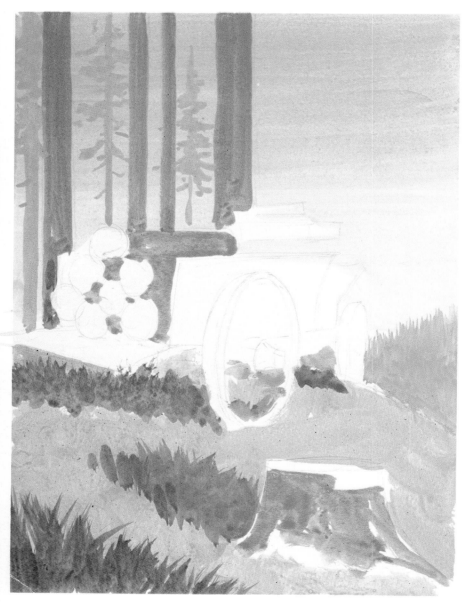

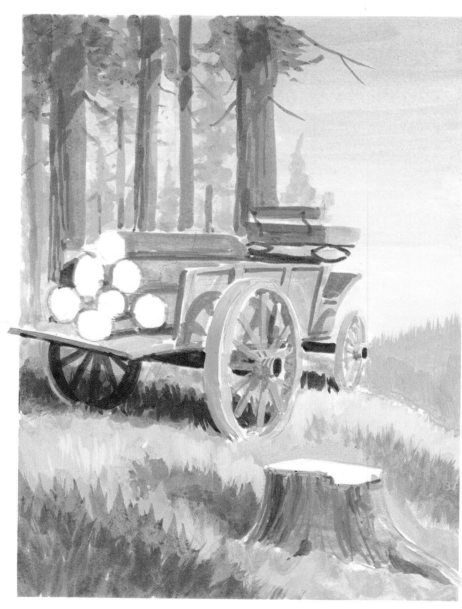

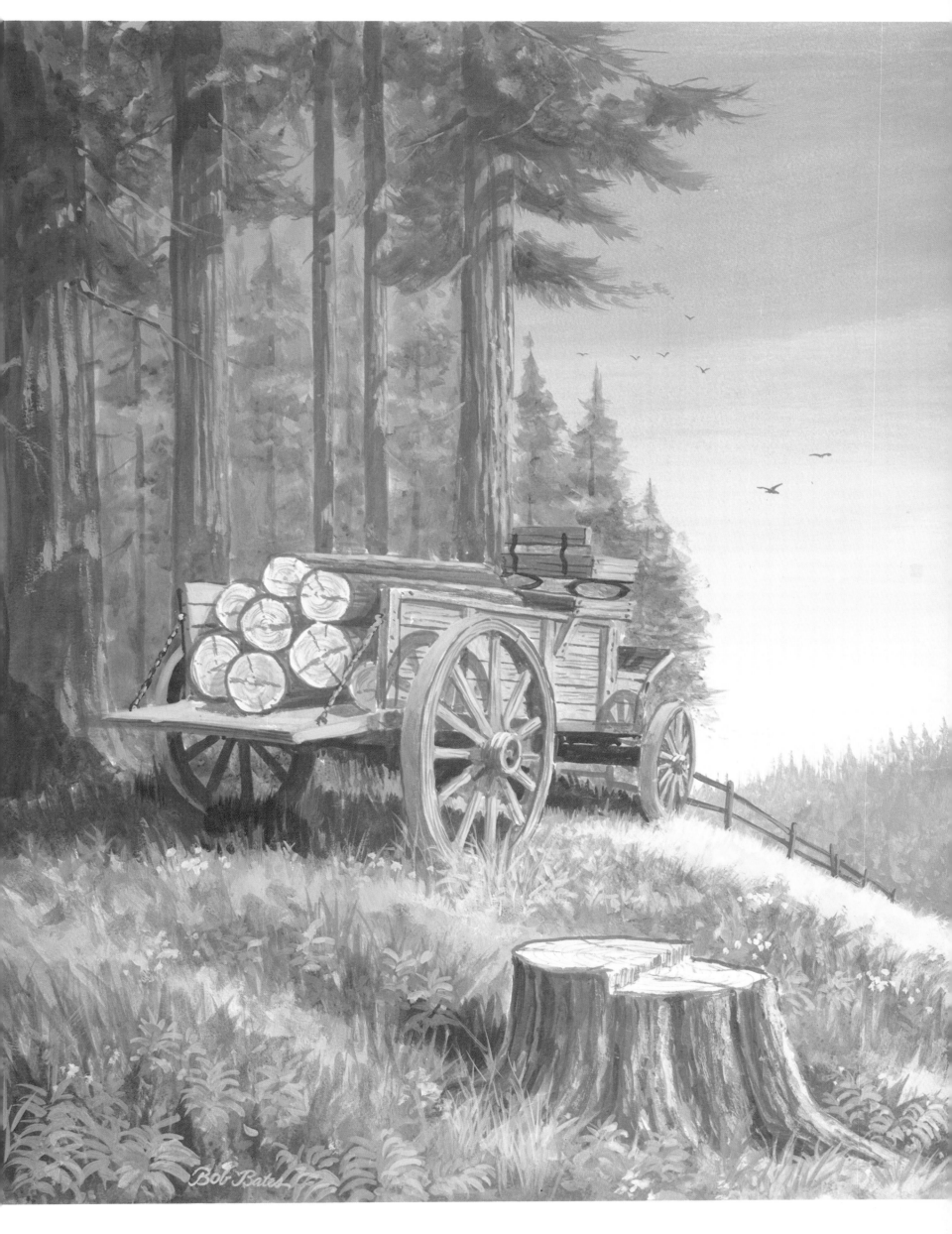

Bob Bates

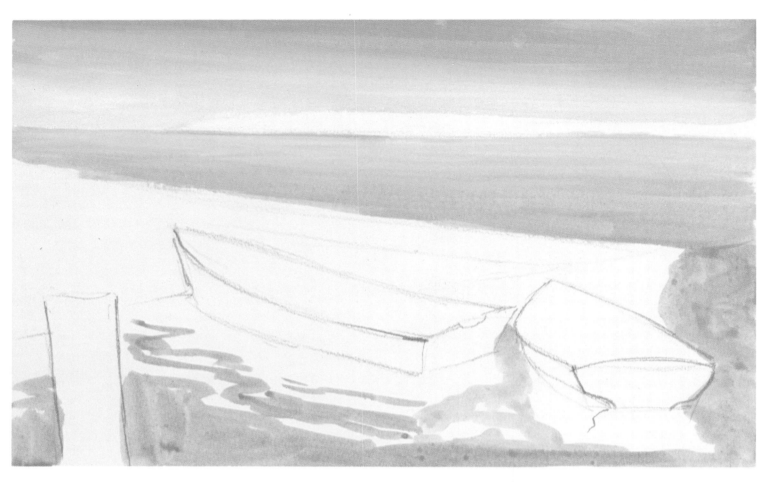

NORTH CAROLINA BOAT DOCK

Before we were lucky enough to travel to North Carolina, we were introduced to it's unusual scenery through the photos of our friend Gail Davidson. Notice the great reflections. I sketched the boat first then started right in on the foreground water.

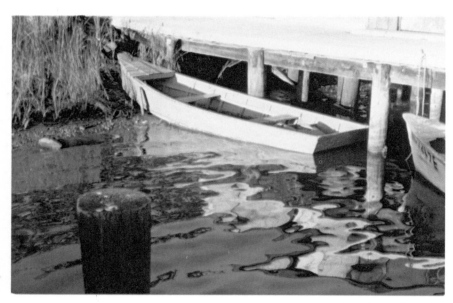

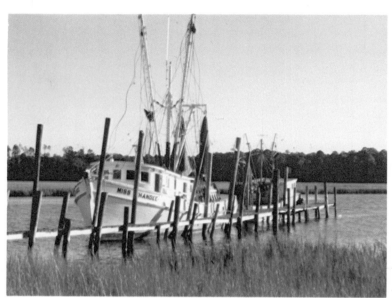

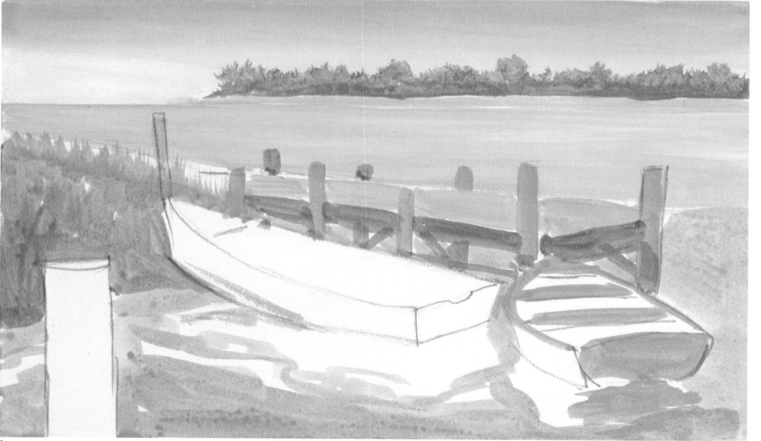

The distant shoreline is very straight. The foreground shoreline slants into the center. Backstroke the distant trees with a #6 brush using Green, Black, Orange, and Burnt Umber.

I used a watercolor technique in this painting which leaves white areas.

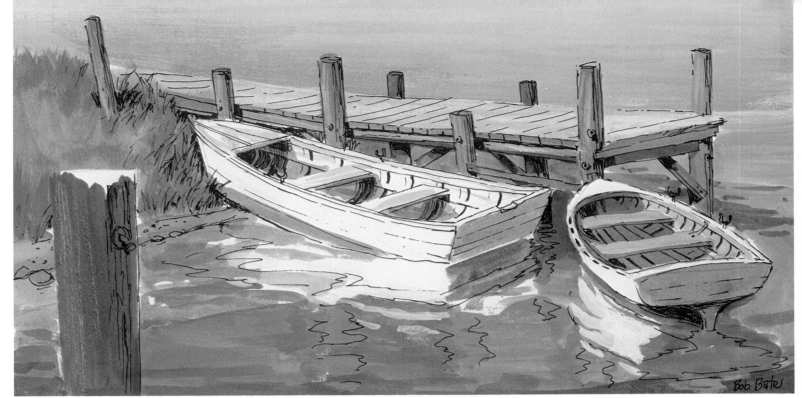

The sketch on the right is a pen and ink watercolor technique. Now that you have finished the painting below, study it for a minute. The gull, small boat, large boat and the direction of the dock, all point you into the center. Most successful painters will try to pull your eye into the center of the painting. You don't want to fall off the edge.

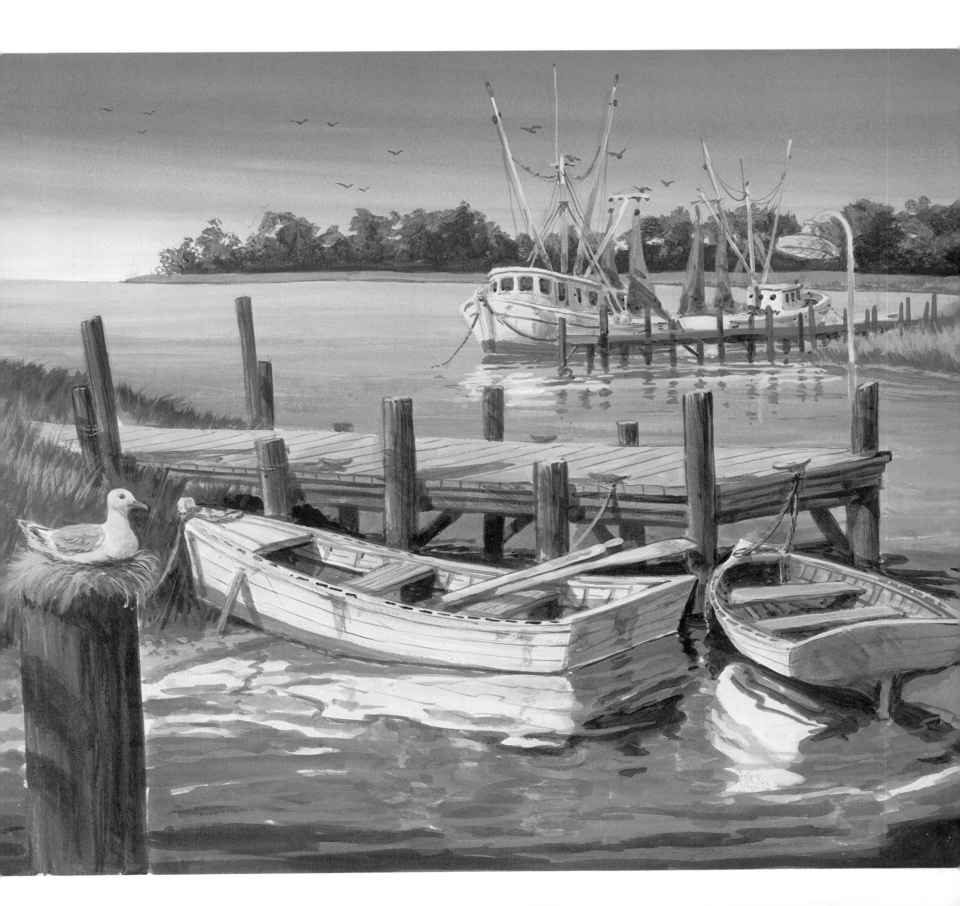

KNOTT'S BERRY FARM STREET SCENE

Knott's Berry Farm, an amusement park in Buena Park, California, is one of my best customers for graphic commercial art. The scene on this page and the page opposite were paintings of the park that I was commissioned to do for them. I painted them in a natural setting, however, and removed the crowds. The perspective gets a bit tricky here with all the different building heights and types. I only show the perspective of one set of buildings but you can see the right has vanishing points way to the left, study them.

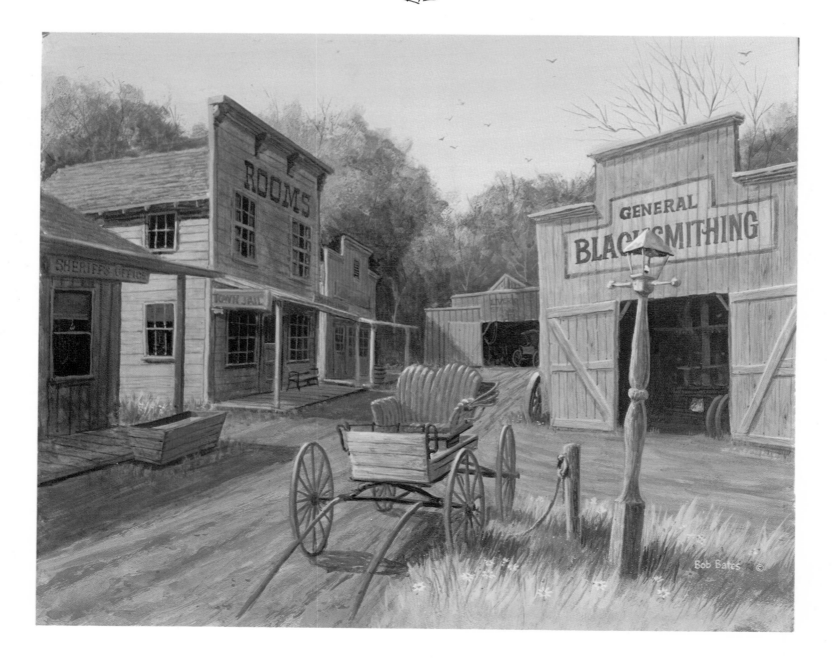

OLD ENGINE No. 41

Old trains are one of my weaknesses, and as Val and I travel around the country. I search out the old trains that are running again. We have taken some very scenic trips.

Painting a train engine can be very difficult, so I gave you a detailed pen and ink to study. Your lines must curve around the tank and smokestack. Perspective is vitally important here. The vanishing point has to be far off to the left so your headlight, side lights, and cow catcher look correct, also notice the for-shortening in the coal car, and passenger cars.

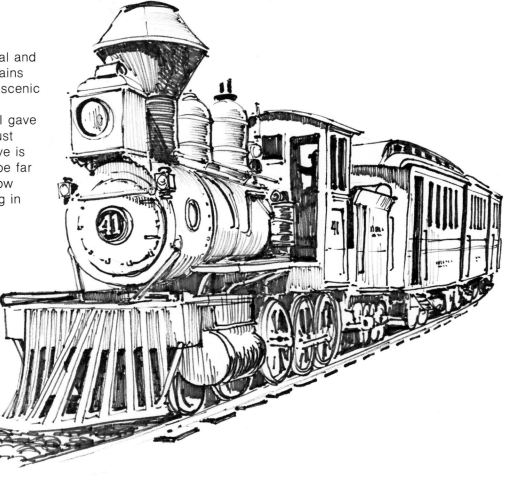

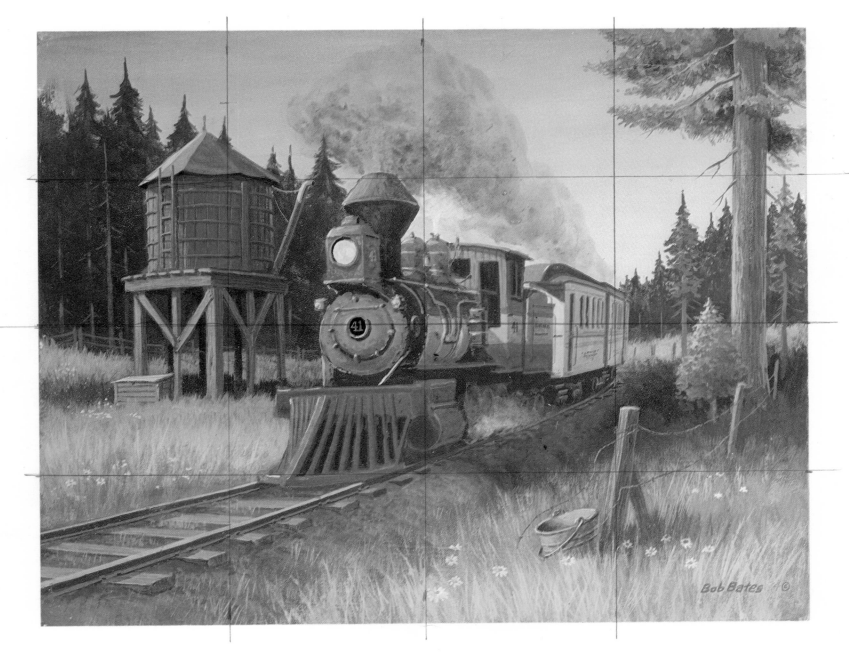

Bob Bates

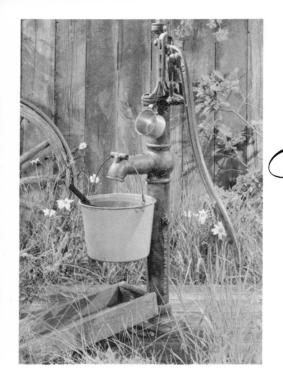

THE OLD WATERPUMP

\mathcal{W}e are conscious once again of the importance of good photographs. I varied the type of pump slightly for the painting. Actually, it would make a painting all by itself, a detail in the distance or as I chose to do, an object in the foreground.

By facing the pump to the left, the eye is drawn into the center of your painting.

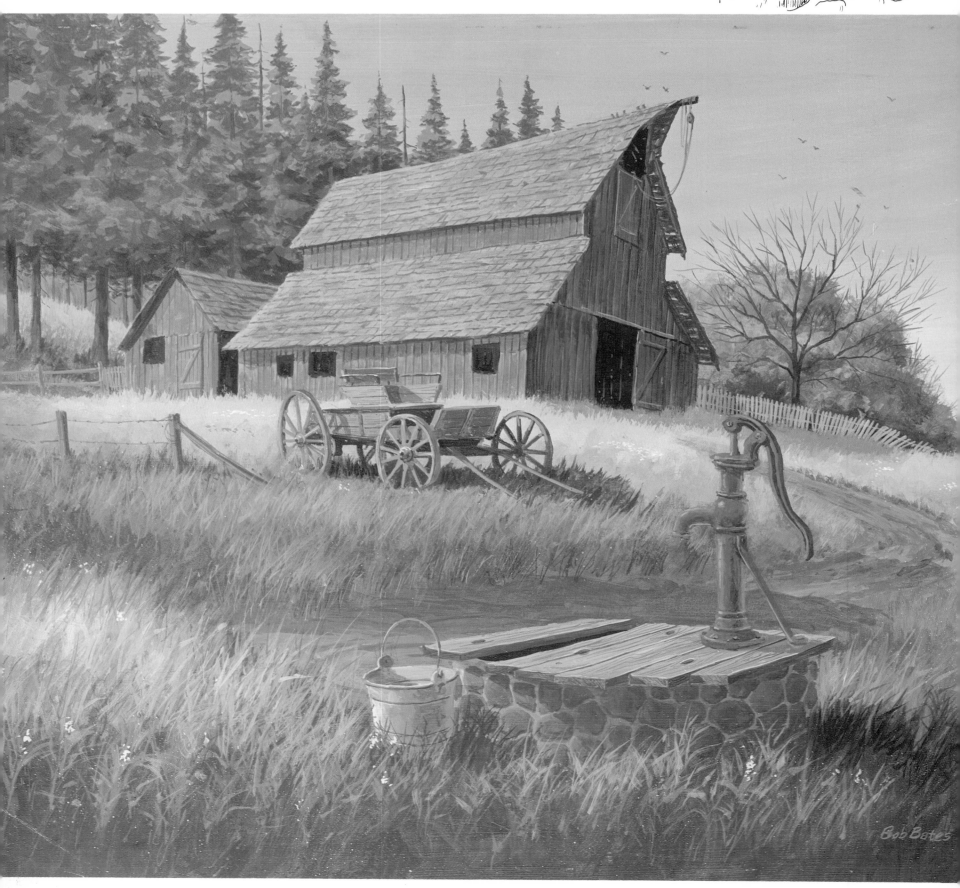

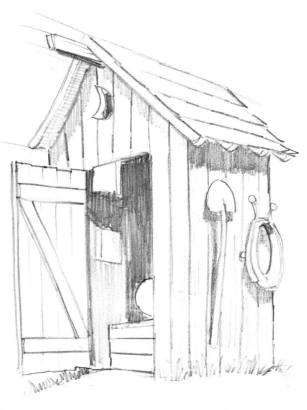

THE LEANING OUTHOUSE

Now for a change of pace and a bit of whimsey. Let's paint an outhouse. They are something from our history most people would like to forget, but a conversation piece in a painting.

This outhouse is painted from one I built in our back yard. It isn't real of course, but people think it is. Notice the use of shadows to create third dimension.

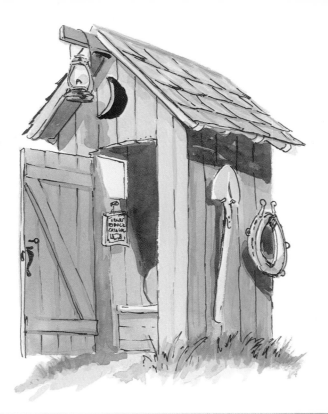

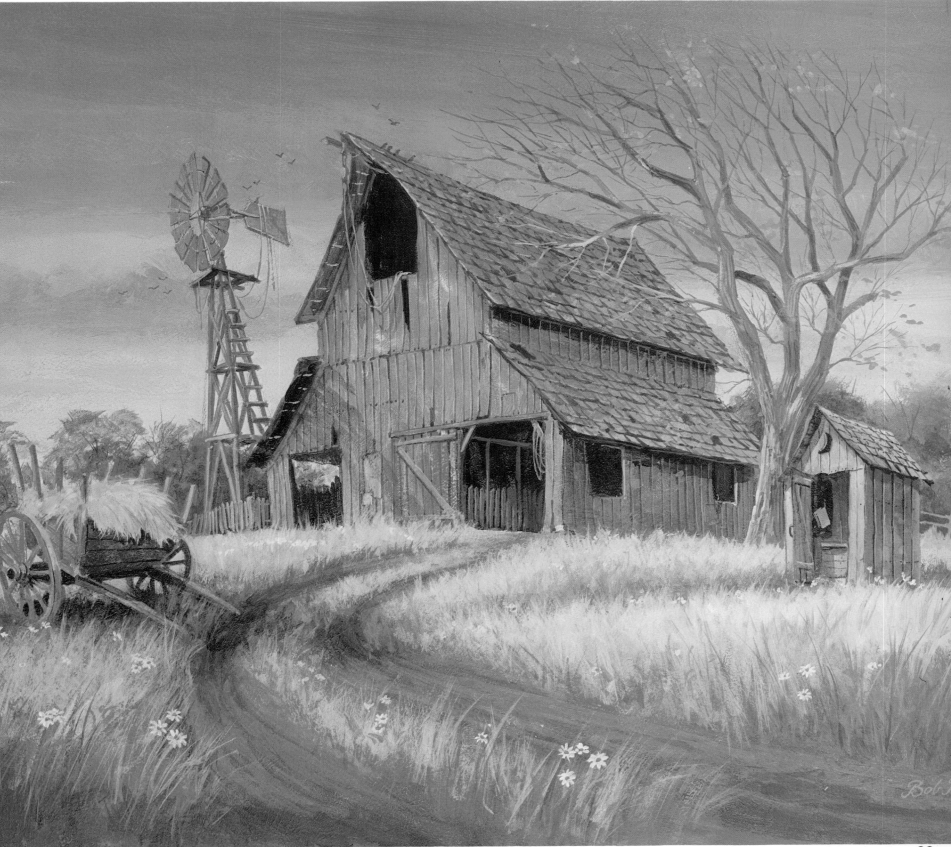

PRIMITIVE PAINTING BY GRANDPA BATES

For years I have admired the style of Grant Wood, Grandma Moses, and more recently, Charles Wysoki. Almost on a dare, I decided to try a primitive for myself. It was love at first try! What fun you can have telling a story or depicting a way of life in just one painting. You can watch each section unfold like a patchwork quilt.

I like to begin by doing a pencil rough to make sure it has design and flow. If a complete painting seems too difficult to begin with, just try a small section such as the mill or the horsecart.

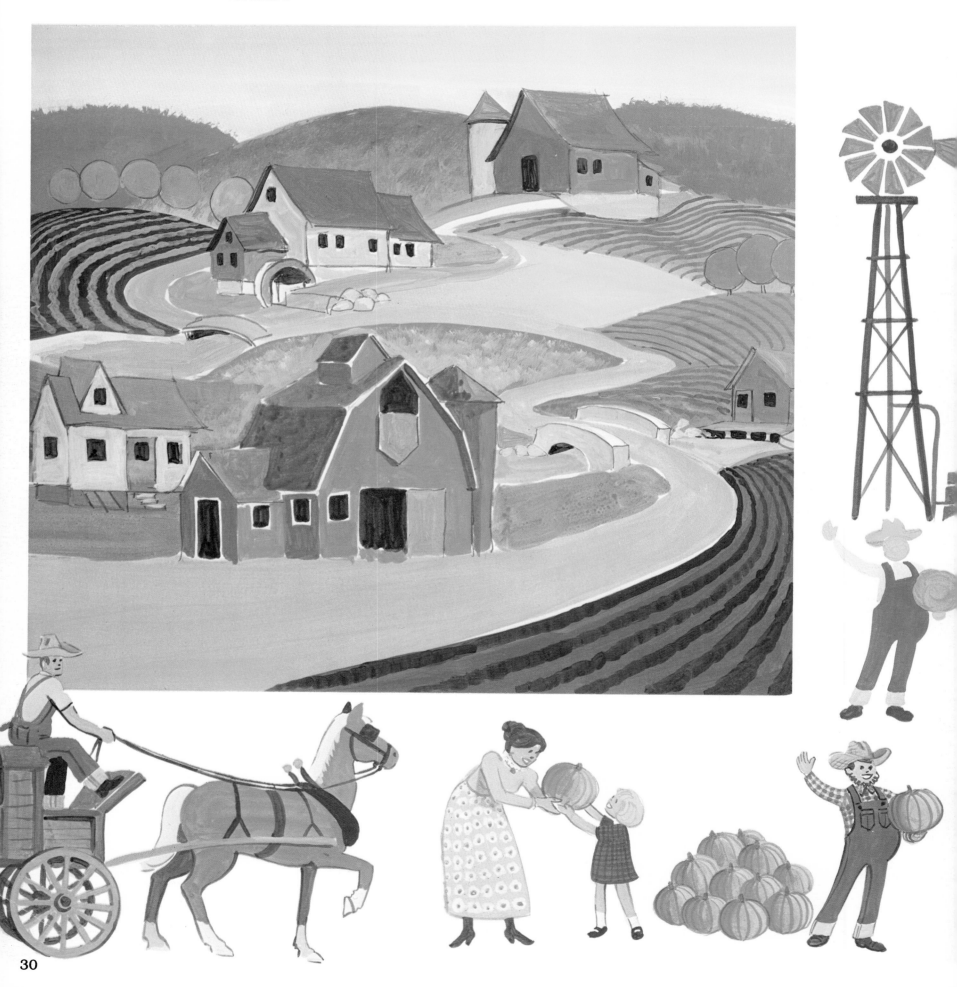

This is really a different style and technique. All we have said about vanishing point, third dimension, shading and shadows, goes right out the window.

The first step is to paint your fields and roads without buildings. Let it dry completely, then add the structures. The people, horses, trees, and flowers are last.

Keep your colors fresh and bright. Work on a crisp, defined feel to everything. I think you will be pleased with the outcome.

We hope to have whetted your appetite for primitives. I am now working on a complete book on the subject. In that book I will break it all down and go into the fine details of a primitive painting. Again we hope to open up new avenues and new Adventures in Acrylics.

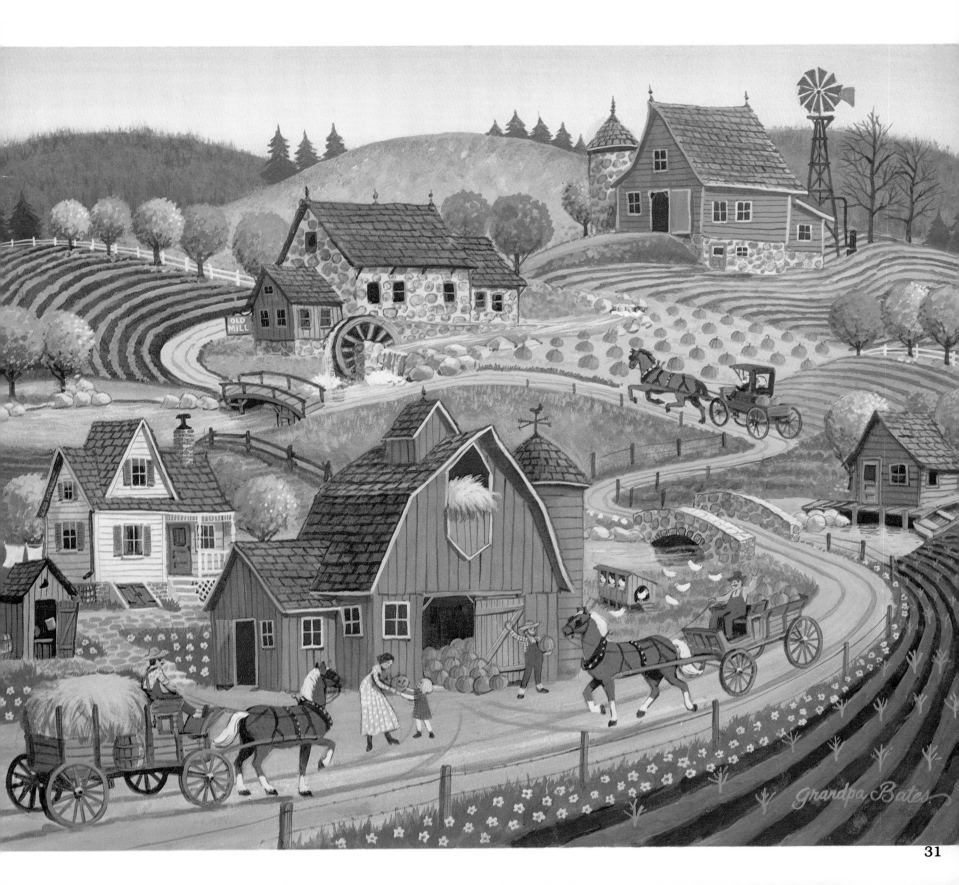